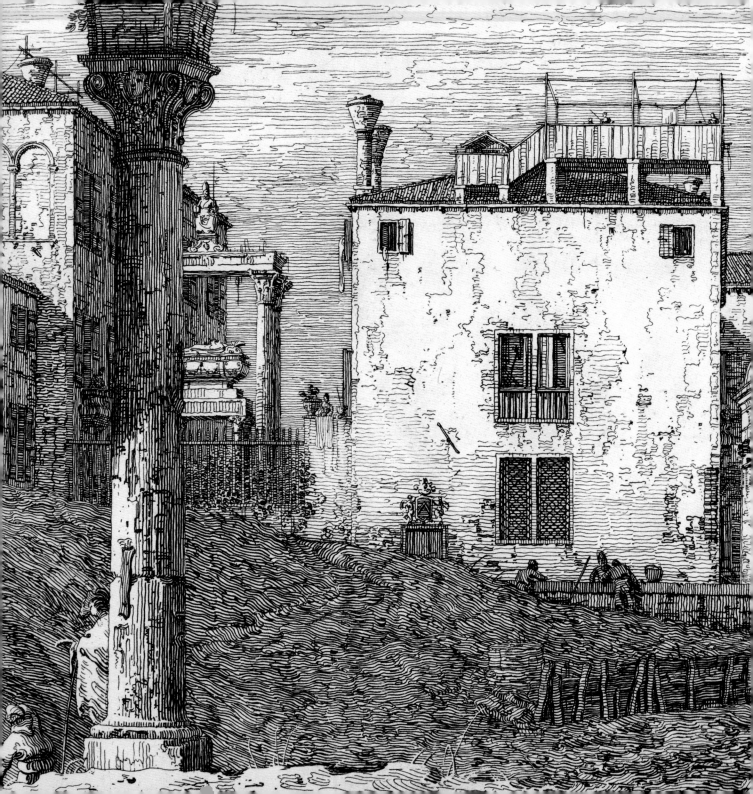

BRUEGEL TO FREUD

PRINTS FROM THE COURTAULD GALLERY

Rachel Sloan

THE
COURTAULD
Gallery

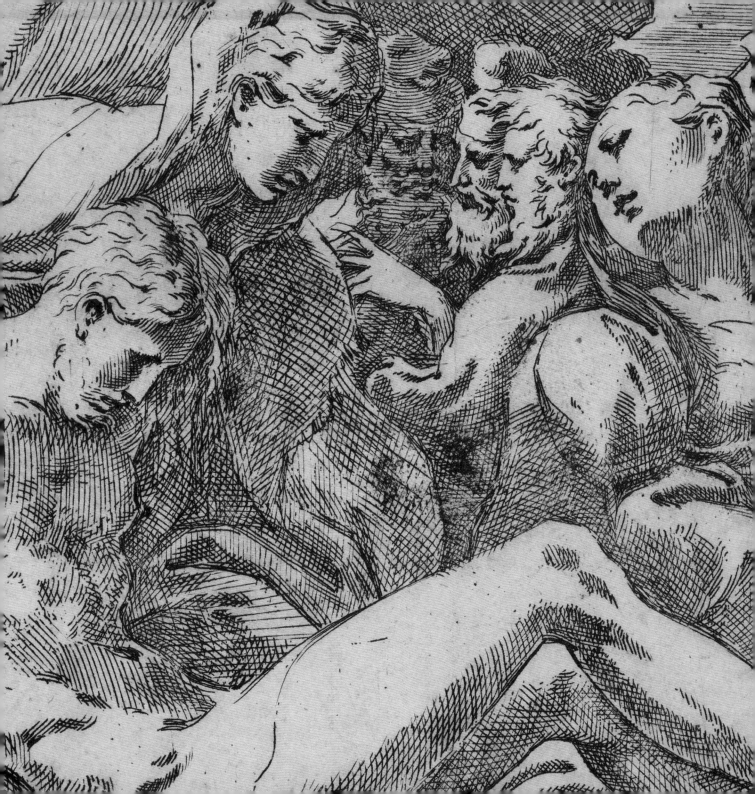

PRINTS FROM THE COURTAULD GALLERY
AN INTRODUCTION

At over 24,000 individual sheets, prints constitute by far the largest portion of The Courtauld Gallery's collection. They range in date from the fifteenth century to the present, representing all schools of Western art, in varying depth, and all of the major printmaking techniques. In a number of ways they exemplify what distinguishes printmaking from other media, for as repeatable images prints have from the beginning functioned as tools of communication and education, be it through disseminating knowledge of an artist's oeuvre in the era before photographic reproduction; conveying information (scientific, historical, geographic and otherwise); or serving as a means of artistic, moral or religious education.[1] At the same time, printmaking has always offered artists a powerful means of original expression and a way to explore effects that cannot be achieved in other media. This essay seeks to introduce The Courtauld's print collection and to give a sense of its special character as a university collection and scholarly resource.

The Courtauld's print collection owes its unique character to its being, in essence, a collection of collections – a quality it shares with the Gallery's collection as a whole. Rather than being an encyclopaedic collection providing a complete history of the medium (indeed, it contains several notable lacunae, not least early impressions of the work of two titans of European printmaking, Albrecht Dürer and Rembrandt), it reflects the diverse and highly individual tastes and goals of the three men who contributed principally to shaping it – Sir Robert Witt (1872–1952), Samuel Courtauld (1872–1947) and Count Antoine Seilern (1901–1978).

The single greatest influence on the size and character of the print collection was Sir Robert Witt, one of the founders of The Courtauld Institute of Art in 1932 and, before that, the creator of the Witt Library. As an Oxford undergraduate in the early 1890s, Witt had begun to collect photographic reproductions of works of art; his future wife, Mary, had a similar collection, and the two were united upon their marriage in 1899. What had begun as an informal hobby had grown, by 1920, when Witt published his first catalogue of the artists represented in the collection, into a collection of approximately 150,000 reproductions representing 8000 artists which he intended to serve as a resource for scholars and students of the history of art, curators, dealers and collectors, the first of its kind in Britain,[2] and which he described as

... a kind of Murray's Dictionary of Pictures and Drawings, by concentrating and bringing together reproductions of, as nearly as may be, the whole body of European painting and drawing, and arranging it as

a Dictionary in the manner most convenient for easy reference.[3]

While the vast majority of the reproductions collected by the Witt Library (which today number over two million) consisted of photographs or cuttings taken from sale and exhibition catalogues, Sir Robert had also by this time extended the library's remit to include reproductive prints, although he made clear in his catalogue that photographs were to be preferred, even though "no form of reproduction is rejected".[4] Despite his background as a dedicated collector of drawings (whose wide-ranging collection of over three thousand drawings has been the nucleus of the Gallery's drawings collection since its bequest in 1952), Witt did not approach prints as a connoisseur. These reproductive prints were treated in the same manner as photographic reproductions, as records in an image bank rather than as works of art in their own right; they were filed first by national school, then alphabetically by the artist whose work they reproduced, rather than by printmaker, and were stored like (and interleaved with) the photographs and cuttings, in boxes on open shelves, either unmounted or stuck down on thin card. In this form, they have been used for teaching and study by generations of scholars and students, both within The Courtauld and outside it. In 1990, owing to concerns about conservation and security, over 20,000 prints were transferred from the Witt Library to The Courtauld Gallery, where they have since been catalogued systematically.

In large part because Witt treated the prints in his library as images rather than as works of art in their own right, and most likely, as well, owing to the sheer volume in which reproductions continued to be acquired (in most cases not directly by Witt himself), no acquisition records were kept. Although we know that scholars periodically donated material to the library (this, for example, was how Johannes Wilde's monumental ten-part engraving by Nicolas Béatrizet after Michelangelo's *Last Judgment* (no. 5) – a tour de force of reproductive printmaking – found its way into the collection)[5] we can only guess how some of the more remarkable sheets entered the library, particularly as Sir Robert had stressed in his 1920 catalogue that "original engravings … original etchings and lithographs altogether, are outside the scope of the library". The proportion of works within the Witt print collection that could be considered 'master prints' in the sense employed by eminent print scholar Adam von Bartsch (1757–1821) in his celebrated series *Le Peintre-graveur* (1803–21) – that is, compositions conceived and executed by artists as original works of art rather than as reproductions of works in other media – is relatively small (almost certainly no more than 10% of the sheets), but notable discoveries have been made during the ongoing cataloguing of the transferred Witt Library prints. These include significant groups of engravings by William Hogarth (nos. 13 and 14) and etchings by Stefano della Bella, Claude Lorrain and Jacques Callot, including a fine impression of the last-named's *Fan* (no. 10); a proof before letters, with handwritten inscriptions, of an engraving by Cornelis Cort after a design by Stradanus of an allegory of the practice of the visual arts (no. 6); and, perhaps most remarkable of all, a unique impression of the first state of an extremely rare etching by the Lorraine Mannerist Jacques Bellange (no. 9).[6]

The Witt Library's original collecting policy had been restricted to artists active before 1850.[7] Representation of nineteenth-century artists was bolstered by the

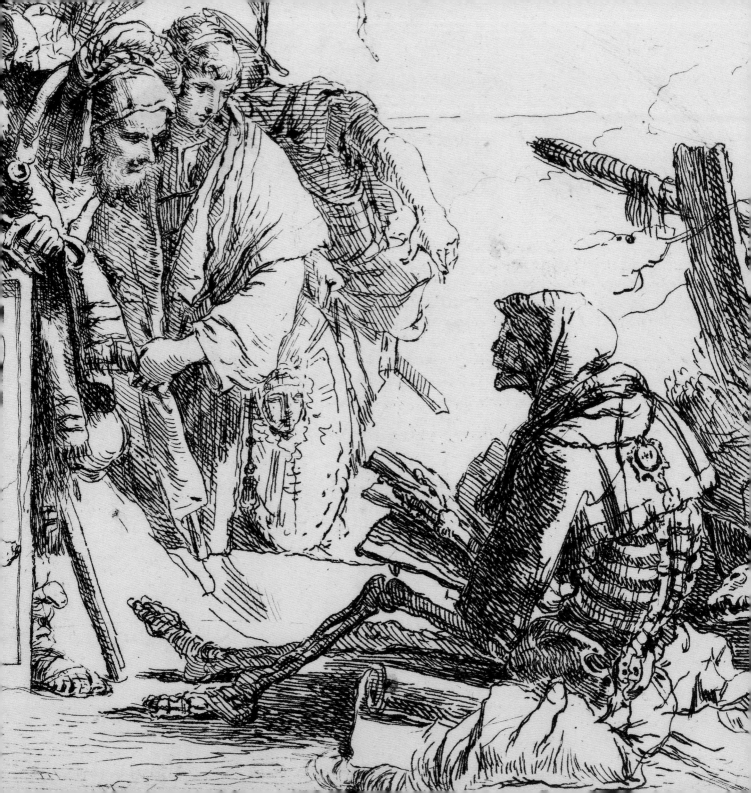

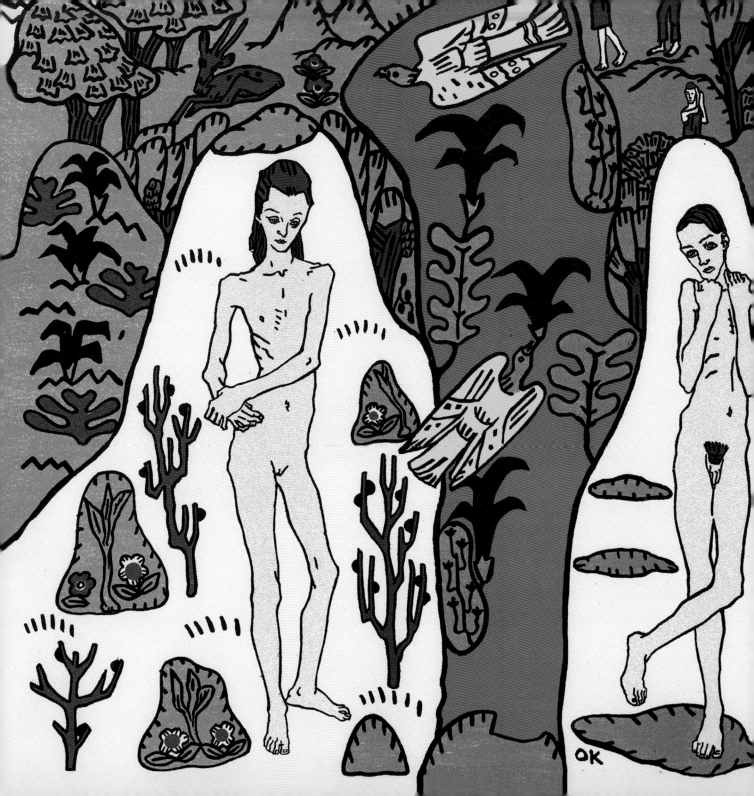

Hampstead Library's donation to the Witt Library, in 1966, of the Cornish Collection. This collection of several thousand prints was particularly rich in Victorian illustrative wood engravings, material which has been enjoying a gradual resurgence of scholarly interest, and included the work of a number of the leading artists in that field – John Everett Millais, Arthur Hughes and Frederic, Lord Leighton among them – as well as work by, or more often after, their French contemporaries.[8]

Many of the 'master prints' in the collection came to The Courtauld through the generosity of Count Antoine Seilern. Seilern, a scholar-collector who emigrated to London from Vienna in 1939, is perhaps best known for his extraordinary collection of Old Master paintings and drawings, which he bequeathed to what is now the Samuel Courtauld Trust for the benefit of The Courtauld Gallery in 1978. Less well known is the collection of prints he formed concurrently, primarily through regular purchases over the period 1951–66. Seilern gravitated naturally to the prints of artists whom he admired as painters and draughtsmen, and his collection was particularly rich in prints by Parmigianino and Giovanni Battista Tiepolo and most especially after Rubens (no. 11), as well as noteworthy single sheets including Bruegel's *Rabbit hunt* (no. 4), the only print directly from this artist's hand. As the acquisition records in The Courtauld Gallery archives make clear, he tended to buy prints alongside drawings, not infrequently purchasing works in different media by the same artist together, as when he acquired a set of Tiepolo's *Vari capricci* (no. 16) along with two of the artist's drawings.[9] This practice reflects the passionate interest he took in all aspects of the creativity of an artist he particularly admired.

Although he treated them with as much care as his drawings, storing them in his library in bespoke boxes of museum quality,[10] Seilern never catalogued his prints, as he had done with his paintings and drawings; he did not consider himself an expert in the field, and may have felt that the magisterial catalogues of Bartsch, Johann David Passavant (1787–1861), Arthur Mayger Hind (1880–1957) and other print scholars rendered his own attempt redundant.[11] He collected prints primarily for the immense intellectual and aesthetic pleasure they afforded him, and, in a rare recorded comment on the subject, lamented the demise of contemporary interest in them.[12] Partly as a consequence of its not being catalogued, Seilern's print collection did not come to The Courtauld in its entirety following his death; his rich holdings of over one hundred woodcuts and engravings by Dürer, an enduring interest from the 1930s until the end of his life, passed to his heirs,[13] and the nearly 300 prints that came to The Courtauld Gallery as part of the Princes Gate Bequest were, with a few unexplained exceptions (such as Hendrik Goltzius's *Pieta*; no. 8), those that related in some way to the paintings and drawings, either being the work of artists already represented in these media or having been made after specific paintings and drawings. (For example, the bequest contained a preparatory study for Mantegna's *Flagellation*; no. 1.)

While Count Seilern's primary art historical interests lay chiefly in the Old Masters, he did not neglect more recent artists. He owned a set of the delicate drypoints Berthe Morisot created in 1889 (no. 19) and, notably, patronised his fellow countryman and émigré Oskar Kokoschka; thanks to Seilern, The Courtauld now holds 96 prints by Kokoschka, including an edition of his seminal artist's book *The Dreaming Youths* of 1907

(no. 23), containing a drawn self-portrait made especially for its recipient in 1962.

Samuel Courtauld's interest in Impressionist and Post-Impressionist art was all-encompassing, embracing drawings and prints as well as paintings.[14] Over the relatively brief period of his main collecting activity, from 1922 to 1929, he acquired more than a hundred prints, all but four of which entered the Gallery's collection in a series of gifts and bequest made between 1932 and 1948. As Count Seilern later did, he tended to buy his prints alongside paintings and drawings, the majority of them purchased through the Leicester Galleries or through Percy Moore Turner, one of his most trusted dealers.

Courtauld's interest in prints generally hews to Douglas Cooper's characterisation of his collection as "essentially a collection of Post-Impressionist works", and consists almost exclusively of work by artist-printmakers.[15] Apart from a small group of prints by what were at the time contemporary British and Continental artists including Walter Sickert, Eric Gill, James Ensor,[16] Edvard Munch and Anders Zorn, his preference leaned overwhelmingly towards French Impressionists and Post-Impressionists, all of whom were represented in his collection in other media. The three artists represented in the greatest depth in his collection were Paul Gauguin, with ten prints (including the *Noa Noa* suite, from the edition printed posthumously by Gauguin's son Pola; no. 20); Henri de Toulouse-Lautrec, with sixteen lithographs, including the *Yvette Guilbert* album and single sheets such as the complex seven-colour *Bust portrait of Marcelle Lender* and the masterly *Jockey* (no. 22); and Edouard Manet, with thirty-one etchings – the album of thirty plates posthumously published by Strolin in 1906, along

with an 1862 impression of *La Toilette* (no. 18), one of Manet's earliest essays in the medium and one of his first attempts at a female nude. Courtauld collected the work of contemporary artists, but, as Anthony Blunt noted, "as far as the Fauves, and even more the Cubists, were concerned, [he] never became a convert".[17] The prints by Picasso and Matisse that he bought were made in the 1920s, a period when both artists temporarily abandoned the radical tendencies of their pre-War work and strove for a more classical approach to the figure. It is worth noting that Courtauld's gift of these prints for the benefit of the newly founded Institute ensured its first students direct access to contemporary works of art.

Courtauld's collecting was always underpinned by a deep personal engagement with individual works of art. Although his prints do not figure in any known photographs of his collection displayed in Home House, he seems to have treated at least a few of his prints in much the same way as his paintings – that is, displaying them more or less permanently in frames as part of a harmonious ensemble with his paintings and drawings. Indeed, several prints, notably those by Picasso, Matisse and Aristide Maillol, exhibit light-staining at the mount line, which suggests that they were kept on view for an extended period in the years between their purchase and subsequent donation.

The Courtauld's print collection has, of course, been enhanced over the years by many other generous gifts and bequests. In 1933, the collector Henry Oppenheimer bequeathed his complete set of Canaletto's *Views of Venice* (no. 15): these were among the first works in any medium, along with early gifts by Samuel Courtauld and Lord Lee of Fareham, to enter the collection. Lillian Browse's 1982 gift of modern French and British works

included, among other prints and drawings, several panels of Pierre Bonnard's extraordinary lithographed folding screen, *The Nannies' Promenade* (no. 21), while Alastair Hunter's 1984 bequest of primarily modern British works brought an etching from Picasso's celebrated *Vollard Suite* (no. 25) into the collection. More recent gifts, including Frank Auerbach's 2012 gift in memory of the artist of ten etchings by Lucian Freud (no. 26) and Charles Booth Clibborn's donation of prints by contemporary artists published by the Paragon Press, including two etchings by Chris Ofili (no. 27), have broadened the scope of the collection and suggested new avenues for future growth.

NOTES

1 I am grateful to Joanna Selborne and Helen Braham for sharing their knowledge of the Witt Library and Princes Gate print collections with me. For an overview of the multifarious functions of prints throughout history, see William M. Ivins, Jr., *Prints and Visual Communication*, Cambridge, MA, 1969.

2 On the Witt Library in comparison with other similar ventures in Europe in the early twentieth century, see Lucy Fernandes, 'The Witt Library, Photograph Collections and Art History in the early twentieth century', MA dissertation, Courtauld Institute of Art, 2009.

3 Sir Robert Witt, *Catalogue of Painters and Draughtsmen Represented in the Library of reproductions of pictures and drawings formed by Robert and Mary Witt*, London, 1920, p. v.

4 Witt 1920, p. vi.

5 See Michael Bury and Katharine Lockett, 'Béatrizet's Last Judgement, after Michelangelo, in the Courtauld Gallery', *Print Quarterly*, XXVIII, no. 3, 2011, pp. 266–71.

6 On the discovery of the first state of Bellange's *Virgin and Child*, see Craig Hartley, *Jacques Bellange, Printmaker of Lorraine*, British Museum, London, 1997, pp. 58–60.

7 Witt in fact set this out as a rule: "[The scope of the Library] aims at completeness, and therefore at including every painter and draughtsman of any repute ... working up to about the middle of the nineteenth century": Witt 1920, p. vi.

8 While no prints from the Cornish Collection are represented in the present volume, several are included in a concurrent display of prints catalogued by Elizabeth Jacklin under the auspices of the Esmée Fairbairn Print Cataloguing project (2012–14). I am grateful to Joanna Selborne for providing background information about this collection.

9 Courtauld Gallery archives, Princes Gate records, receipt from Colnaghi dated 29 July 1952. Seilern acquired nearly all the Old Master prints he purchased in London through Colnaghi, whether by direct purchase or using the firm to act as his agent at auctions. The provenance of the prints he acquired in Vienna before he emigrated is unknown.

10 The Courtauld Gallery archives, Princes Gate records.

11 Helen Braham, verbal communication, 21 March 2014.

12 Letter from Count Antoine Seilern to A.E. Popham, 15 June 1951, British Museum Print Room archives, volume of letters received 1949–56 ("It is deplorable, but the interest for prints is diminishing").

13 Seilern's Dürer prints were later sold at auction in 1998; see sale catalogue 'Albrecht Dürer: Prints from the Collection of the Late Count Antoine Seilern', Christie's, London, 8 July 1998.

14 On Samuel Courtauld as a drawings collector, see Stephanie Buck, 'Mastery on Paper: Drawings at The Courtauld Gallery', in Stephanie Buck and Colin B. Bailey (eds.), *Mantegna to Matisse: Master Drawings from The Courtauld Gallery*, London, 2012, pp. 19–22.

15 Douglas Cooper, *The Courtauld Collection: A Catalogue and Introduction*, University of London, The Athlone Press, 1954, p. 10.

16 The print by Ensor was among the works Courtauld bequeathed to family and close friends; see Cooper 1954, p. 174. Most of the remainder of the prints Courtauld gave for the benefit of the Institute are mezzotints after J.M.W. Turner.

17 Anthony Blunt, 'Samuel Courtauld as a Collector and Benefactor', in Cooper 1954, p. 3.

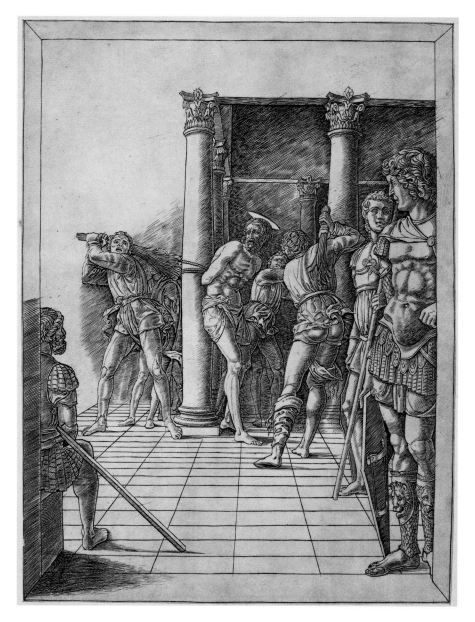

1

Andrea Mantegna (Isola di Carturo 1430/31–1506 Mantua)
The Flagellation, c. 1465–70, engraving, 442 x 343 mm (sheet)
Princes Gate Bequest, 1978, G.1978.PG.6

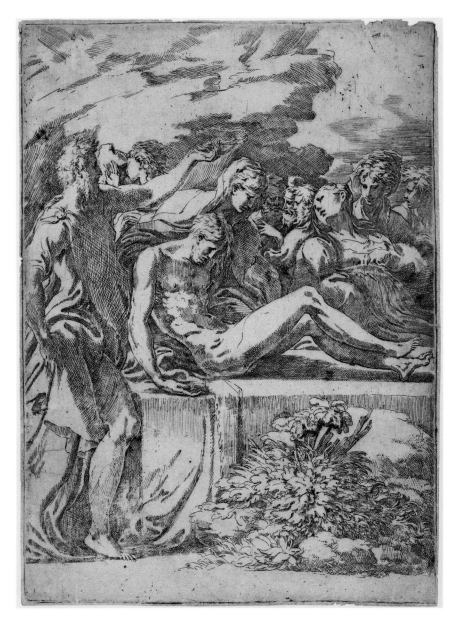

2

Parmigianino [Girolamo Francesco Maria Mazzola] (Parma 1503–1540 Casalmaggiore)
The Entombment, before 1530, etching, state ii/ii, 329 x 239 mm (plate mark)
Princes Gate Bequest, 1978, G.1978.PG.36

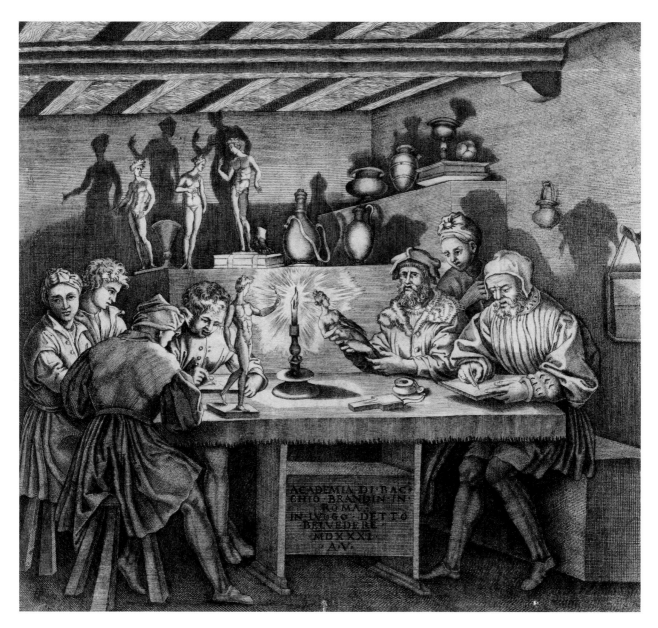

3

Agostino Veneziano (Venice c. 1490–after 1536 Rome)
after Baccio Bandinelli (Gaiole in Chianti 1493–1560 Florence)
The Academy of Baccio Bandinelli, 1531, engraving, 270 x 296 mm (cut within plate mark)
Witt Library Transfer, 1990, G.1990.WL.19

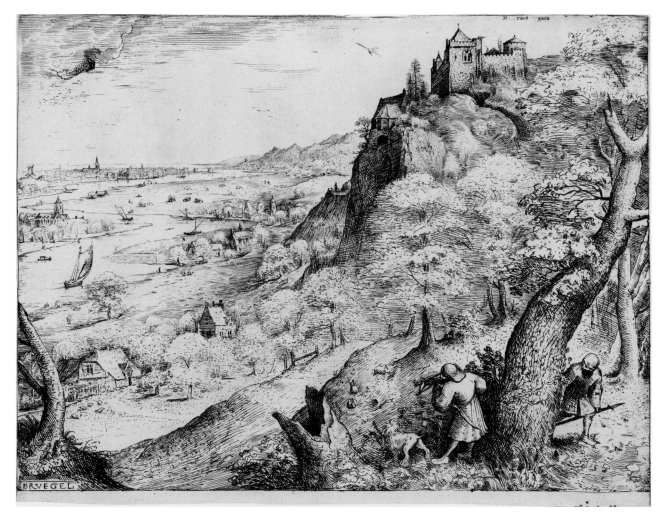

4

Pieter Bruegel the Elder (Breda c. 1525/30–1569 Brussels)
Rabbit hunt, 1560, etching, 222 x 299 mm (sheet)
Princes Gate Bequest, 1978, G.1978.PG.1

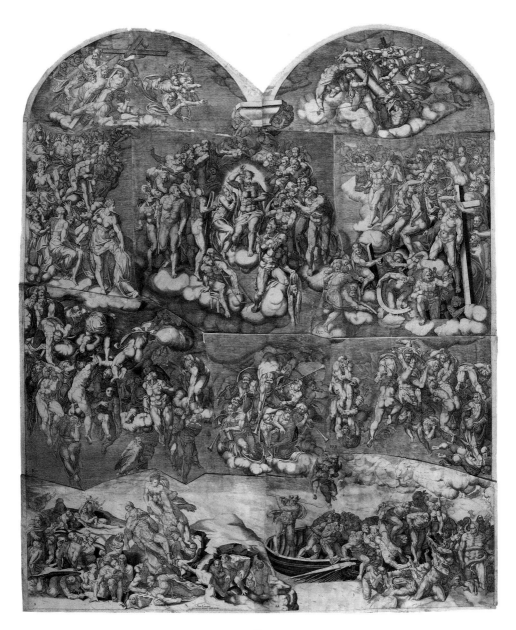

5

Nicolas Béatrizet (Thionville 1507/Lunéville 1515–c. 1565 Rome)
after Michelangelo Buonarroti (Caprese 1475–1564 Rome)
The Last Judgment, 1562 (published 1620), engraving from ten plates, 1225 x 1055 mm
Johannes Wilde Bequest, 1970, G.1970.XX.27

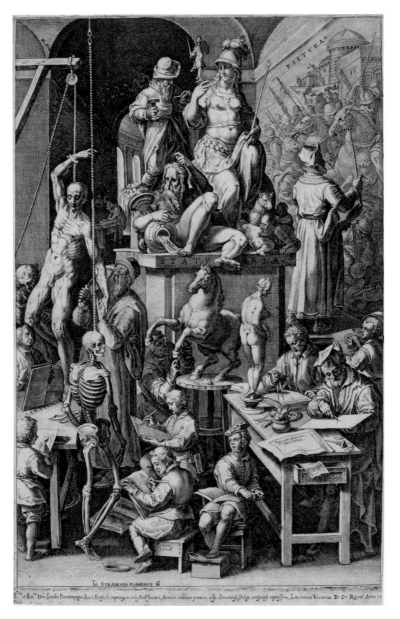

6

Cornelis Cort (Hoorn 1533–1578 Rome)
after Johannes Stradanus [Jan van der Straet] (Bruges 1523–1605 Florence)
The Practice of the Visual Arts, c. 1573, engraving with inscriptions in ink, 444 x 296 mm (sheet)
Witt Library Transfer, 1990, G.1990.WL.1000

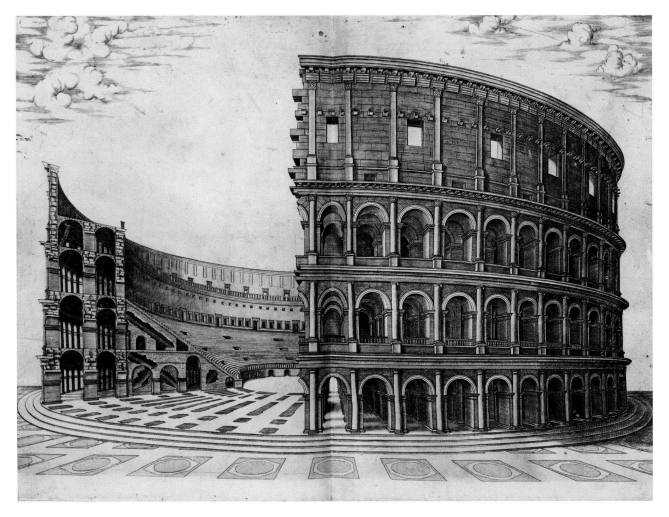

7
Various engravers, published by Antoine Lafréry (Orgelet 1512–1577 Rome)
Speculum Romanae Magnificentiae, 1575, bound volume with engravings and etchings,
varied dimensions (illustrated: *The Colosseum*, 418 x 568 mm (cut within plate mark))
Princes Gate Bequest, 1978, B.1978.PG.102

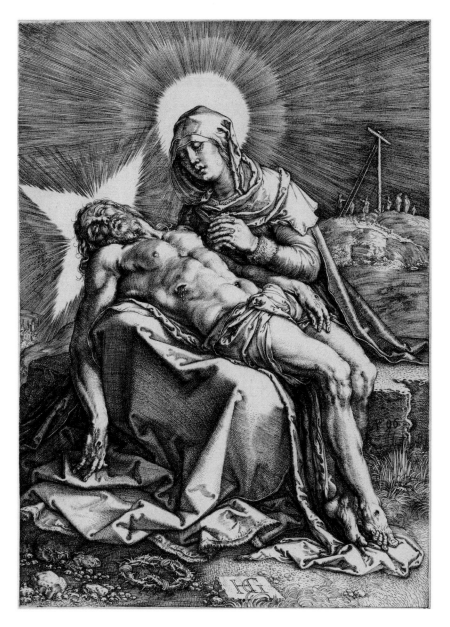

8

Hendrik Goltzius (Bracht-am-Niederrhein 1558–1617 Haarlem)
The Pieta, 1596, engraving, 172 x 122 mm (cut within plate mark)
Princes Gate Bequest, 1978, G.1978.PG.84

9

Jacques Bellange (Bassigny c. 1575–1616 Nancy)
The Virgin and Child, c. 1612–16, etching, state i/iii, 144 x 213 mm (cut within plate mark)
Witt Library Transfer, 1990, G.1990.WL.1565

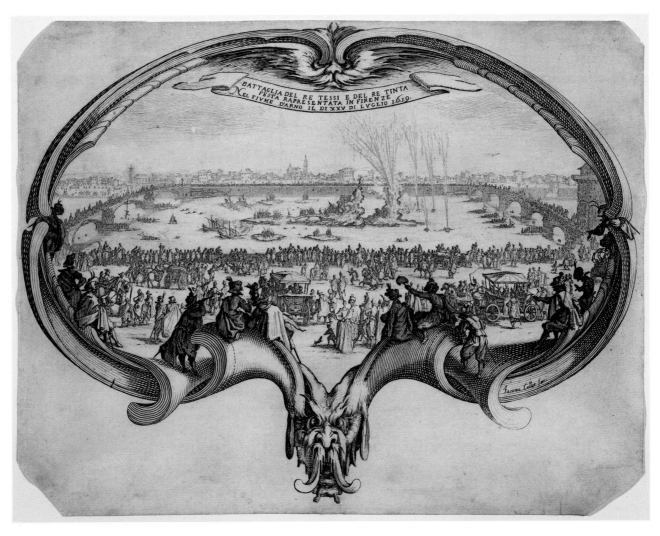

10

Jacques Callot (Nancy 1592–1635 Nancy)
The Fan [*The Battle of King Weaver and King Dyer*], 1619, etching, 227 x 300 mm (cut within plate mark)
Witt Library Transfer, 1990, G.1990.WL.3806

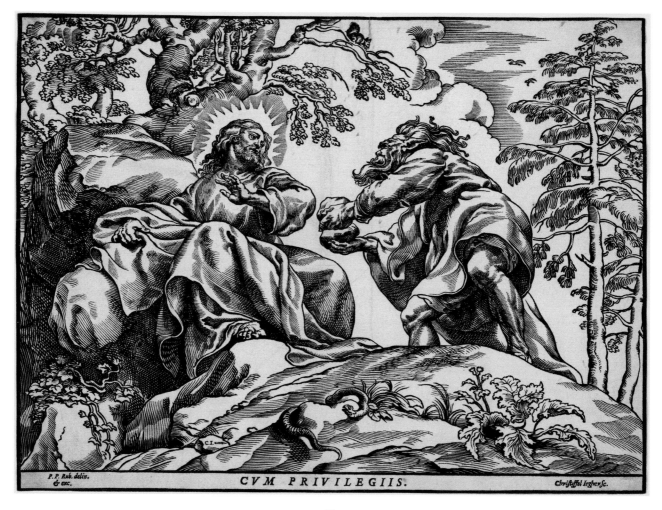

11

Christoffel Jegher (Antwerp 1596–1652/53 Antwerp)
after Peter Paul Rubens (Siegen 1577–1640 Antwerp)
The Temptation of Christ, 1633, woodcut, 325 x 433 mm (cut to border)
Princes Gate Bequest, 1978, G.1978.PG.62

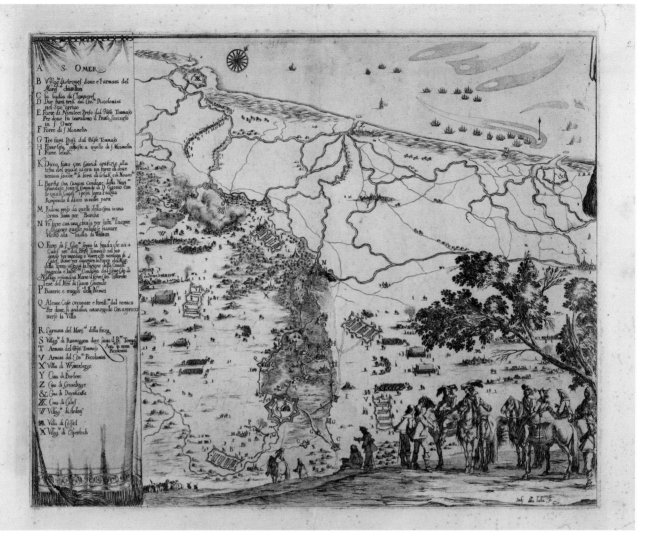

12

Stefano della Bella (Florence 1610–1664 Florence)
The Siege of Saint-Omer, 1638, etching, 378 x 468 mm (plate mark)
Princes Gate Bequest, 1978, G.1978.PG.24

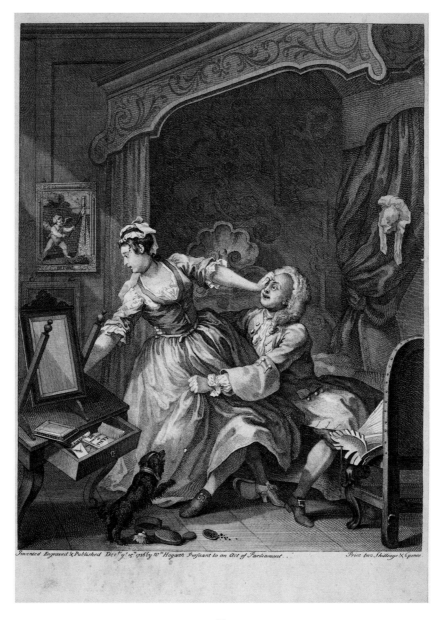

13
William Hogarth (London 1697–1764 London)
Before, 1736, engraving, 425 x 313 mm (cut within plate mark)
Witt Library Transfer, 1990, G.1990.WL.2005

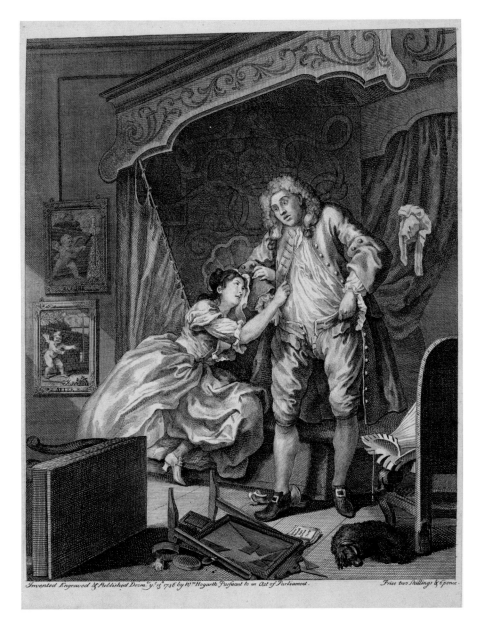

Invented Engraved & Published Decm.y: 15 1736 by W.m Hogarth Pursuant to an Act of Parleament. Price two Shillings & 6 pence.

14

William Hogarth (London 1697–1764 London)
After, 1736, engraving, 404 x 316 mm (cut within plate mark)
Witt Library Transfer, 1990, G.1990.WL.2006

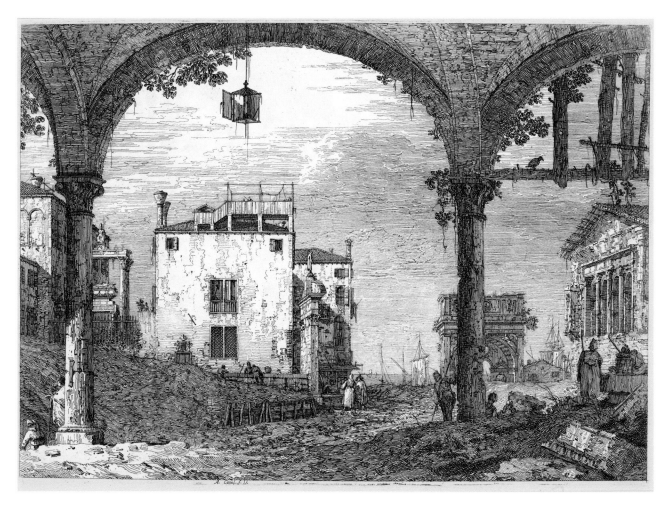

15

Canaletto [Giovanni Antonio Canal] (Venice 1697–1768 Venice)
Portico with a lantern, c. 1741–44, etching, 298 x 431 mm (plate mark)
Oppenheimer Bequest, 1933, G.1933.HO.1.11

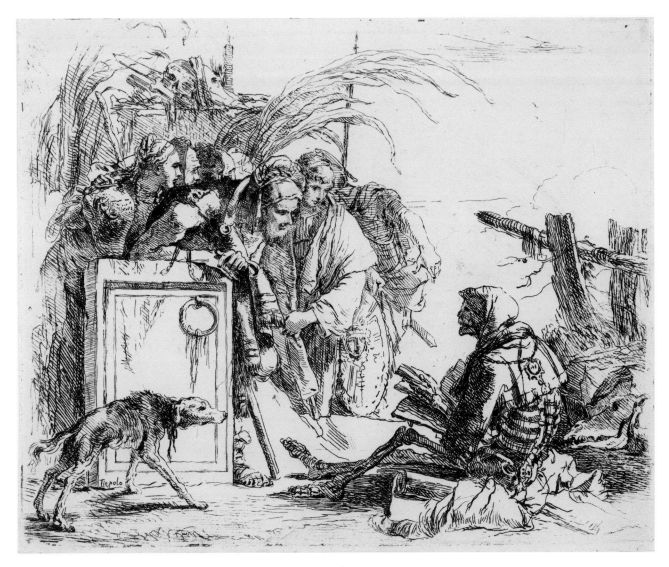

16

Giovanni Battista Tiepolo (Venice 1696–1770 Madrid)
Death giving audience, 1743, etching, 145 x 179 mm (cut within plate mark)
Princes Gate Bequest, 1978, G.1978.PG.13

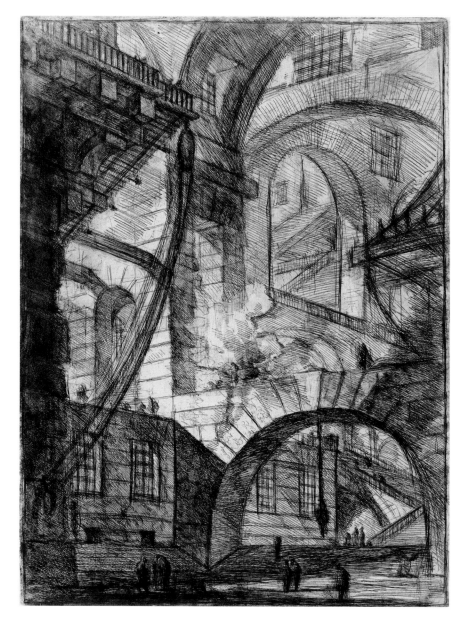

17
Giovanni Battista Piranesi (Mogliano 1720–1778 Rome)
Smoking fire, c. 1749–60, etching, 545 × 413 mm (plate mark)
Princes Gate Bequest, 1978, G.1978.PG.44.4

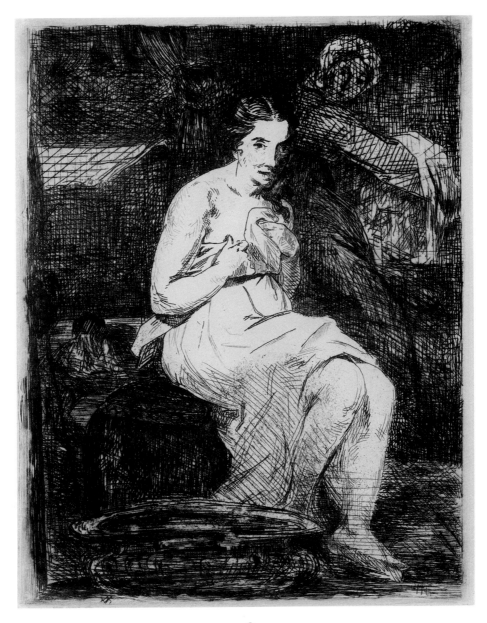

18

Edouard Manet (Paris 1832–1883 Paris)
La Toilette, 1862, etching, 284 x 224 mm (plate mark)
Samuel Courtauld Gift, 1935, G.1935.SC.188

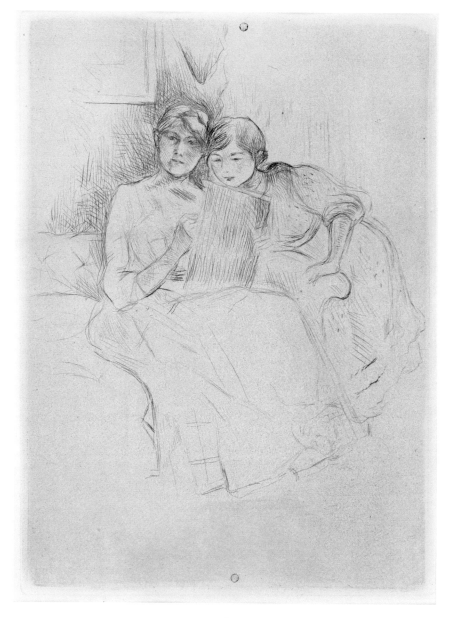

19

Berthe Morisot (Bourges 1841–1895 Paris)
Berthe Morisot drawing, with her daughter, 1889, drypoint, 190 x 138 mm (plate mark)
Princes Gate Bequest, 1978, G.1978.PG.71

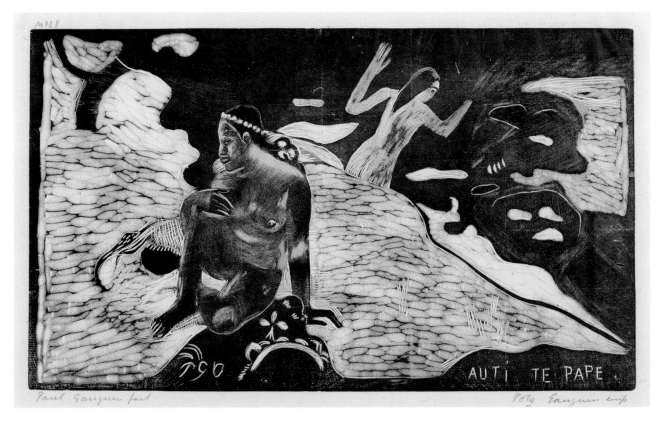

20

Paul Gauguin (Paris 1848–1903 Atuona, Marquesas Islands)
Auti Te Pape (*The Women at the River*), 1893–94 (printed 1921), wood engraving, 205 x 355 mm (image)
Samuel Courtauld Bequest, 1948, G.1948.SC.182.8

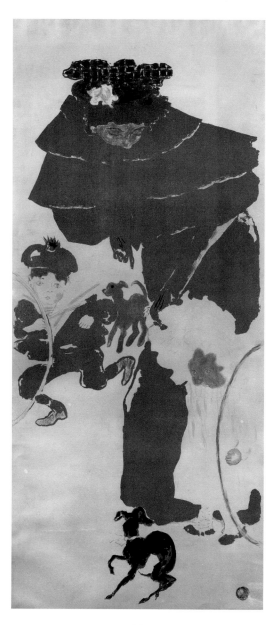

21

Pierre Bonnard (Fontenay-aux-Roses 1867–1947 Le Cannet)
Woman with children and dog (part of a panel from the screen *The Nannies' Promenade*), 1897,
lithograph, 1029 x 457 mm (sheet – cut down from original size)
Lillian Browse Gift, 1982, G.1982.LB.2.4

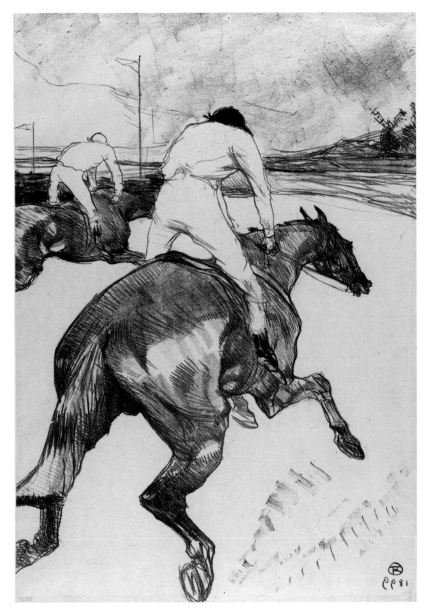

22

Henri de Toulouse-Lautrec (Albi 1864–1901 Malromé)
The Jockey, 1899, lithograph, 516 x 363 mm (image)
Samuel Courtauld Gift, 1935, G.1935.SC.209

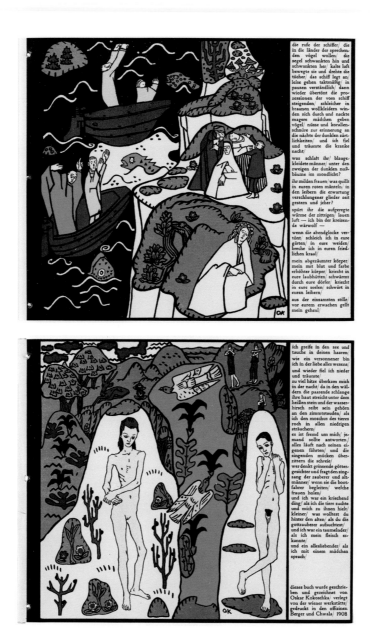

23

Oskar Kokoschka (Pöchlarn 1886–1980 Montreux)
The Dreaming Youths: Boatmen calling and *The girl Li and I*, 1907 (published 1908 amd 1917),
bound volume of lithographs, 240 x 293 mm each
Princes Gate Bequest, 1978, G.1978.PG.88

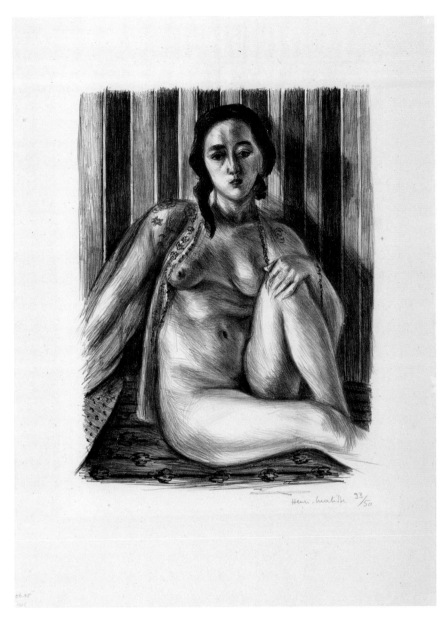

24

Henri Matisse (Le Cateau-Cambrésis 1869–1954 Nice)
Seated nude woman, with a tulle blouse, 1925, lithograph, 443 x 313 mm (sheet)
Samuel Courtauld Gift, 1935, G.1935.SC.195

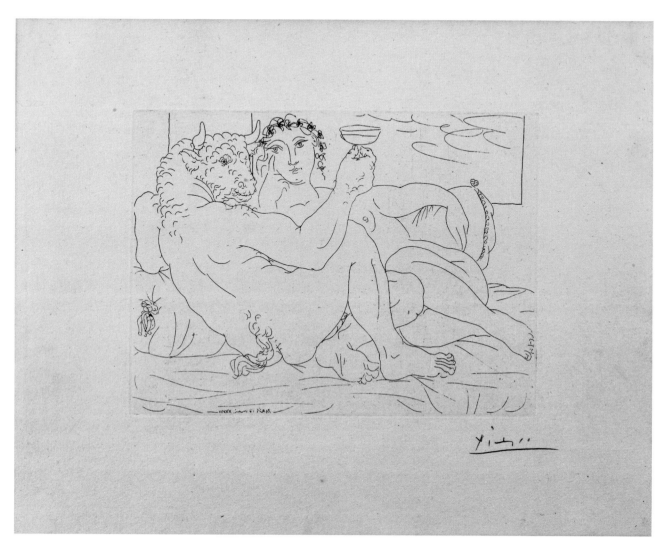

25
Pablo Picasso (Malaga 1881–1973 Mougins)
Drinking Minotaur and reclining woman, 1933, etching, 193 x 270 mm (plate mark)
Alastair Hunter Bequest, 1984, G.1984.AH.24

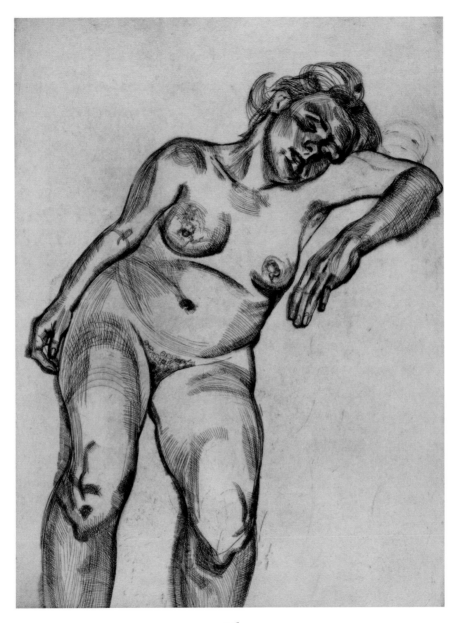

26

Lucian Freud (Berlin 1922–2011 London)
Blond girl, 1985, etching, 690 x 542 mm (plate mark)
Frank Auerbach Gift, 2012, G.2012.XX.8

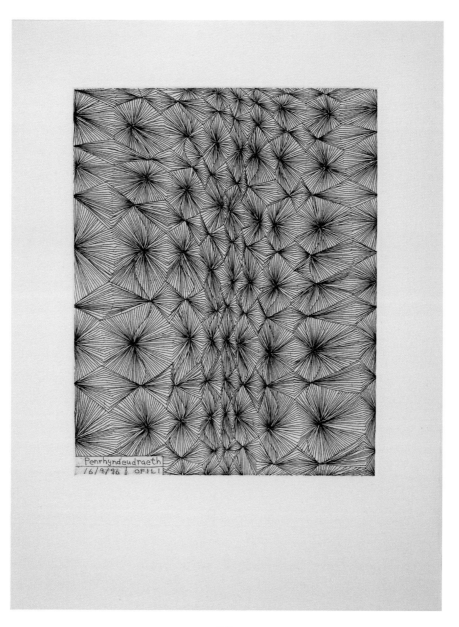

27

Chris Ofili (b. Manchester 1968)
North Wales: Penrhyndeudraeth 16.9.96 (Plate 9), 1996, etching, 248 x 196 mm (plate mark)
Charles Booth Clibborn Gift, 2010, G.2010.XX.25

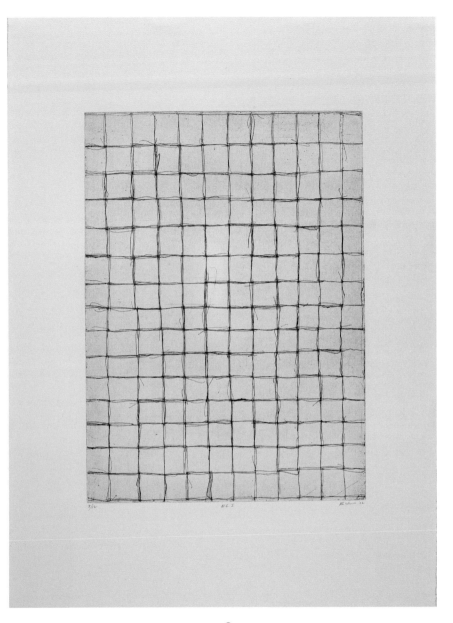

28

Linda Karshan (b. Minneapolis 1947)
N.E. I, 2002, etching, 400 x 300 mm (plate mark)
Purchased with the support of Städelscher Museums-Verein, Frankfurt am Main, G.2014.XX.1

First published to accompany

BRUEGEL TO FREUD: PRINTS FROM THE COURTAULD GALLERY

The Courtauld Gallery, London, 19 June – 21 September 2014

The Courtauld Gallery is supported by the
Higher Education Funding Council for England (HEFCE)

HIGHER EDUCATION *hefce*
FUNDING COUNCIL FOR ENGLAND

ISBN 978 1 907372 68 1

British Library Cataloguing in Publication Data
A catalogue record for this book is available from the British Library

Produced by Paul Holberton publishing
89 Borough High Street, London SE1 1NL
www.paul-holberton.net

Designed by Laura Parker
www.parkerinc.co.uk

Origination and printing by E-graphic, Verona, Italy

FRONT COVER Toulouse-Lautrec, *The Jockey* (no. 22)
BACK COVER Bruegel the Elder, *Rabbit hunt* (no. 4)